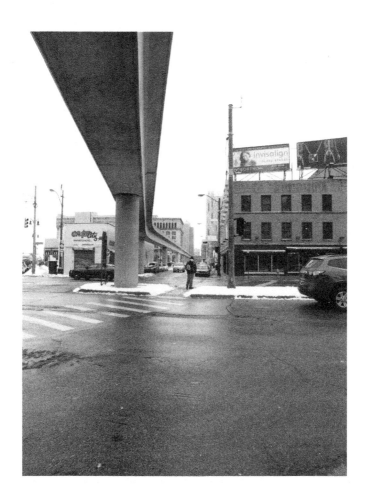

Published in the United States of America by
Michigan Publishing
Manufactured in the United States of America

Designed by Ingrid Ankerson

Support for this publication comes in part from the Penny W. Stamps School of Art & Design

ISBN 978-1-60785-379-4

An imprint of Michigan Publishing, Maize Books serves the publishing needs of the University of Michigan community by making high-quality scholarship widely available in print and online. It represents a new model for authors seeking to share their work within and beyond the academy, offering streamlined selection, production, and distribution processes. Maize Books is intended as a complement to more formal modes of publication in a wide range of disciplinary areas.
http://www.maizebooks.org

LOOPING DETROIT

A PEOPLE MOVER TRAVELOGUE

Nick Tobier

For 75 cents, you can buy a token and ride the People Mover, the self-driving monorail 50 feet above downtown Detroit's ground. You can ride all day—you may even have the train to yourself. Or you can descend at any stop and consider the terrain, each conversation, sighting, or associative memory a portal into worlds (beyond) all within a 1,000-yard radius.

I ride it a lot—occasionally for utility, more often for solitude, and, in the course of this project, for rumination. I invited contributing artists and writers to join me and board and descend the People Mover at a given stop with the minimal brief of "anything that would not be in a tourist's guide to the city."

I asked, I suppose, for poetic reverie and kept stumbling into politics, and vice versa. *Looping Detroit* started as a ride with an itinerary involving getting off at each stop, an agenda to create new habits of use, and counter existing patterns of the People Mover. Namely, that the People Mover is used primarily as a way to get from your car to downtown office buildings, sports arenas, convention halls, or the casino without ever touching a sidewalk in Detroit.

That may have been the goal—it may still be. My urban legend recorder says this small circle was an investment in the downtown of a city still reeling from urban unrest that had been brewing for decades but surfaced most publicly in July of 1967 as the Detroit rebellion and the Detroit riots. For suburbanites who were uncertain of the city, the People Mover offered the promise of safety, and commuters continue to drive through the city's neighborhoods, park in secure garages downtown, and take the train to work at the fortified Renaissance Center without having to touch the ground.

Easy on. Easy off.

Mall developers call this the dumping strategy. Get consumers in front of where they want to be. For the People Mover, this is the Cobo Center (especially once a year for a few frigid January weeks for the Detroit International Auto Show), for hockey fans the Joe Louis Arena, Greektown for gamblers, or Astoria Bakery for the odd ethnic adventurer looking for a long lost pastry. Cadillac, that's the French explorer—or the car. Or, for the commuter, a parking structure. But on ordinary weekdays, after 9am, while the People Mover is moving...not so many people are moving. Still.

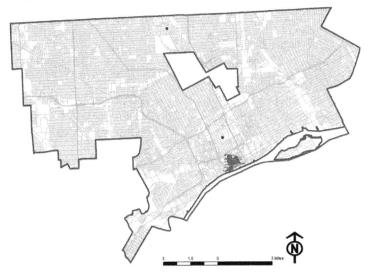

The City of Detroit in relationship to The People Mover

At 139 square miles, the relative scale of Detroit can be conjured by mentally placing the geographic boundaries of Boston and San Francisco and the borough of Manhattan within the city limits. At an aggregated 117 square miles, there is still room in Detroit after superimposing those metropolitan masses. By contrast, the People Mover serves 2.9 square miles. In a collection called *Transit Maps of the World*, the London Underground is Medusa-dense, a tangle of schematic designs making sense of lines from all across the city and their transfer points. There is Massimo Vignelli's 1974 NYC transit map, abstracting the transit system from the physical city by losing references to physical landmarks. As Detroit's rapid transit line, the

People Mover occupies maybe ⅟₃₂nd of a page in the book of maps. For one of the physically largest cities in this compilation, Detroit's little loop speaks volumes.

At just under three miles or five minutes, the elevated driverless train is perhaps not an all-day train journey with respect to terrain. (Imagine the equivalent 12-24 hours: Montreal to Washington DC, Portland to San Diego, Paris to Istanbul.)

Built in 1987, the People Mover was the next big thing. In 1964.

And although we call it the People Mover, most would call this automated, driverless transit car a monorail, which, when not at Disney or between airport terminals, may end up as only an asterisk in the archive of urban transport.

In the mid-1970s everyone wanted one. Sixty-eight cities wrote the Federal government that they wanted one. Thirty-eight municipalities wanted one enough to submit full-blown proposals. Three were completed: in Jacksonville, Miami, and Detroit.

What do we say now? Can we forgive Detroit City Councilman Mel Ravitz, who, in 1985, when the press called the People Mover a Transit Disaster, said, "But if we were starting over, I'd say, 'Don't build it.'" Round and around a 210-million-dollar carousel, read the *Los Angeles Times* headline).

In the intervening years, with fewer than 30 percent of the riders Detroit residents, the People Mover had been called "The Train to Nowhere," "The Mugger Mover," "The Downtown Bobsled Run," "The Rich Person's Roller Coaster," and "The Horizontal Elevator to Nowhere," and other names. While the People Mover has suffered its share of detractors, little has changed in its role or form—aside from that the train ran counter-clockwise until July 2008, when to correct for wear on the rails, the People Mover started running clockwise.

Detroit People Mover ridership soars on Saturdays when there are sports events—currently baseball, football, and hockey, and soon Detroit's basketball franchise, the Pistons, will move back from the suburbs of Auburn Hills. During the 2005 Super Bowl, the train racked up 215,000 riders in one day; another spike occurs each January during the North American Auto Show. This is often called Bread and Circus planning, where arenas and entertainment complexes are built in the underutilized downtowns of "legacy cities" (Cleveland, Pittsburgh, Detroit, Columbus) and the accompanying transportation infrastructure is tailored to suit the needs of the suburban visitors while the outlying areas of the city are left untouched. In Detroit, as in other legacy cities, the relationship between suburbs (largely

white and affluent) and cities (largely black and less affluent) is continually exacerbated by these moves. From the time of its inception, the line inscribed above ground by the People Mover traverses the former of these territories, while the ground below has been the domain of the latter—up until recently.

Looping Detroit takes a train line as the spine for an explorer's journey—the Trans-Siberian, the Patagonian, or a commuter's daily, whether it be the People Mover or NYC's Number 7 subway rising out of its subterranean depths in Manhattan as it crosses the East River into Queens with station stops in a myriad of complex, layered ethnic communities, from south Asian in Jackson Heights to Colombian in Corona or Chinese in Flushing. This mode of exploratory travel across under-heralded terrain is inspired in part by literary antecedents—notably Francois Maspero's (1994) *Roissy Express*, which winds its way through villages and suburbs along the train line from the Charles de Gaulle Airport to Paris. Along a vast suburban distance, the RER line passes through town centers, housing projects, and locales that few tourists to central Paris would visit, yet scores pass through on this train line from the center of the city to Charles de Gaulle Airport. In Maspero's prose and Anaik Franz's photos, each stop is a narrative linked by a voyager who rides the train for the experience of the journey—both on and off the train.

The journey's utility in *Looping Detroit* is for introspection, not transit, through the inspection of geographies and culture. The trip transposes the submerged and often blurry, ordinary lives of commuters into poetic encounters, prompted simply by getting on and off the train.

Looking around the city via the train's trajectory offers passing glimpses of buildings and pedestrians, visible through the window of the train, linking the train's speed to the speed of thoughts. Grounding these thoughts are the station platforms and the stairs connecting these platforms to the city below. I used the ideal infrastructure of the People Mover's elevated platforms to experience what de Certeau writes of the train journey as a "bubble of panoptic and classifying power—somewhere other than a usual destination" (de Certeau. *The Practice of Everyday Life*: p. 111). From the platform, the rider has a view maybe like that of a low-flying bird, where one can see both Detroit's skyline and its ground, passing through tangles of covered walkways piercing buildings. As above, so below? The city framed from the elevated line is distant—something at home in Fritz Lang's visions for future cities in the 1927 film, *Metropolis,* or the equally dystopian view of Paul Verhoven's 1987 film, *Robocop*. Set in a fictionalized, Detroit-like

city where the ground below is lawless and the Renaissance Center towers gleam above, Robocop's take on the ground below is filled with dark streets and denizens of a post-apocalyptic ruin preying on one another. Where the elevated People Mover at one time appeared as a glimpse of the future—*a driverless train!*—its track casts a perpetual shadow over the city below. Looking up at the train, the views beyond the People Mover track frames images that would be at home in another urban near future dystopia, *Blade Runner*. In this film, Ridley Scott's 1982 science fiction is a vision of a city divided between above and below. The elevated portions reflect a technological domination, and earthly pains and pleasures anchor the ground level. Existing within the same space as one another, opposing present tenses are borne out above and below the People Mover stations.

I advocate riding the People Mover with an exploratory charge, where the train becomes the central axis that, along with each stop's ecosystem of buildings, streets and pedestrians, is a source of discovery. In each of these instances in Detroit, while the next stop is between 42 seconds and one minute away, the willing urbanite—resident or visitor—can encounter a complex array of questions and conditions to challenge the notion of distance as a marker of an exploratory voyage.

—*Nick Tobier*

Portions of this introduction appeared in "Small Loop for a Large City" in the journal, *Infinite Mile*, January, 2015

REFERENCES

François Maspero. *Roissy Express: A Journey through the Paris Suburbs*. Photographs by Anaïk Frantz. Translated by Paul Jones. London: Verso 1994.

Peter Eisinger, *The Politics of Bread and Circuses: Building the City for the Visitor Class* Urban Affairs Review 2000 35: 316

John McCarthy, *Entertainment Led Regeneration: The Case Of Detroit*, Cities, Vol. 19, No. 2, pp.105-112, 2002

Michel de Certeau. *The Practice of Everyday Life*. Translated by Steve Randall. Berkeley: University of California Press, 1984.

James Risen, "People Mover in Detroit Seen as Transit Disaster" *Los Angeles Times* Dec. 8, 1985. http://articles.latimes.com/1985-12-08/news/mn-14803_1_detroit-people-mover

Is Sesame Street live?

The platform at Grand Circus Park is filled with red Elmo twirly toys that spin.
Around and around, at the hands of a whole lot of little white children holding them.

It's a short ride—stay on past your stop and you go around and around. Again.
One Elmo pokes me in the eye. Better Elmo than the giant Tiger a block away.

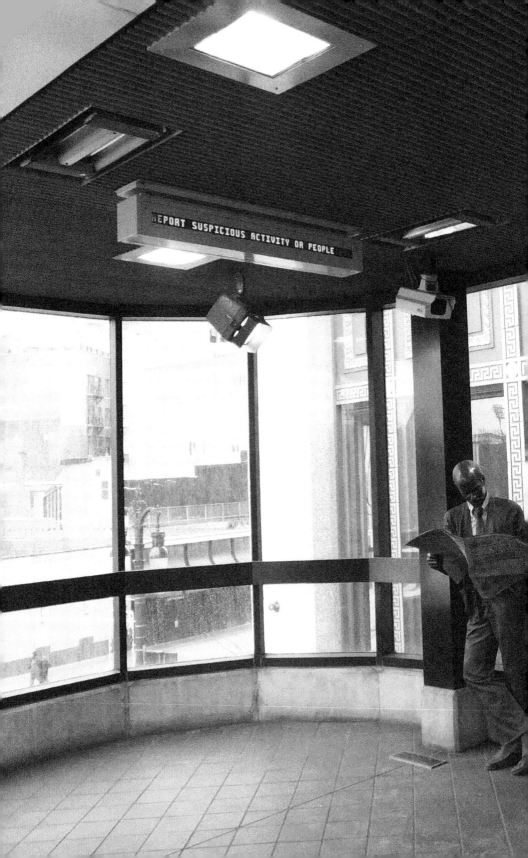

GRAND CIRCUS PARK

Grand Circus Detroit. City
in the realm of electricity,
YESTERDAY MORNING. yesterday morning.
ON THIS SPOT, ENLISTED by the people of born in Detroit
the city of Detroit in The people of Detroit to erect this monument to
commemoration early this morning, Erected have erected
this monument. was the first to awake to the great commemoration of
the achievements of The officer To the officer, and public official
The citizens of this eloquent citizen citizen, four times the people. the park
threatened loving and successful walking about the cherished memory of
corporations, of the great danger charity and taxation and to an enterprising
ordering persons to a life of unselfish asylum at central CIRCUS PARK
public found with a by powerful private name as AS PRIVATE got tired of
the grass. Educated in inequalities in sympathy in dedicated from the first
watching to see that station, where no one took gallant reform. service
had been staying there and and was The idol of any flowers.

— Mary Lum

Sesame Street is surely live today.

You can see the Fox Theater from up here—one restored showplace down-town that brings the suburbs to the city to see Elmo do his thing on stage.

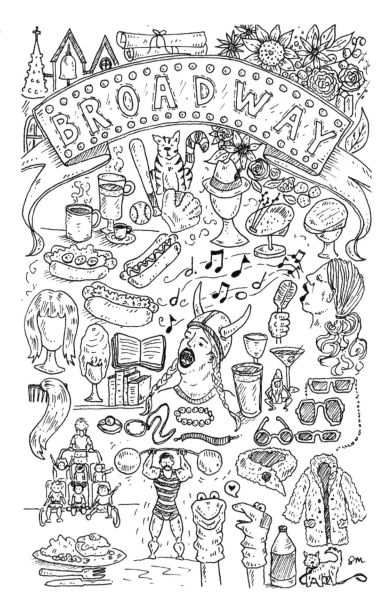

— *Stacy Malasky*

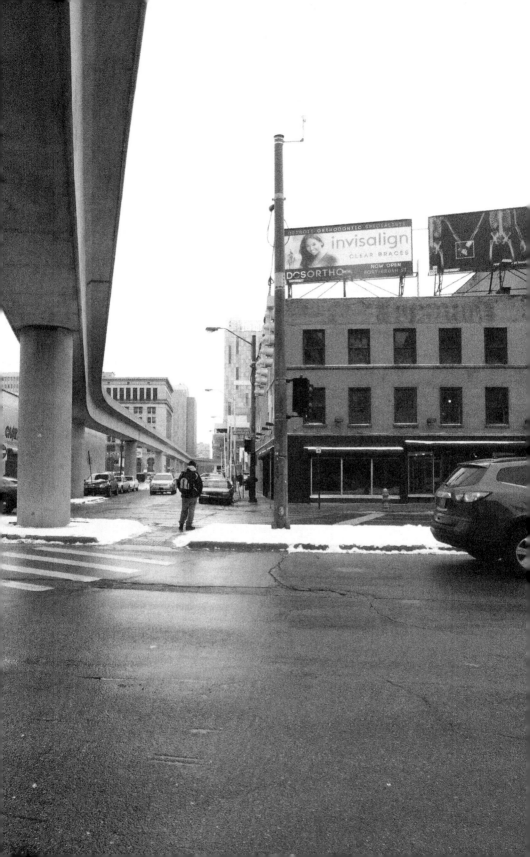

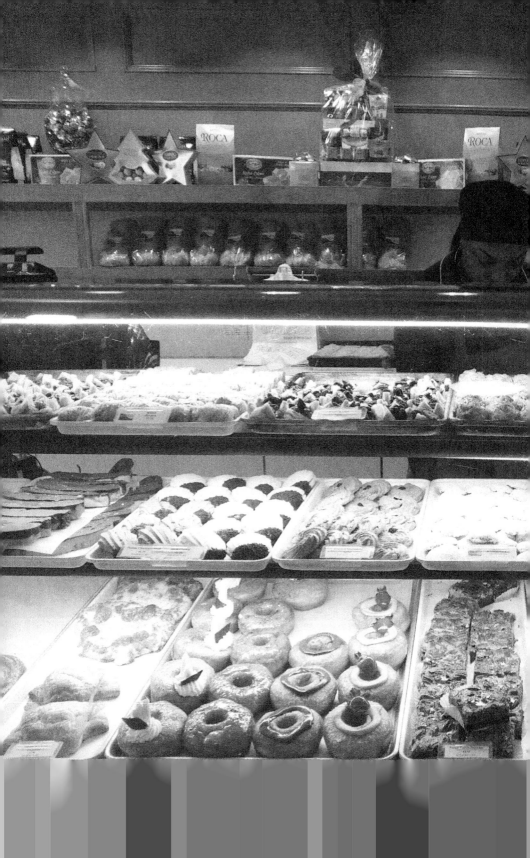

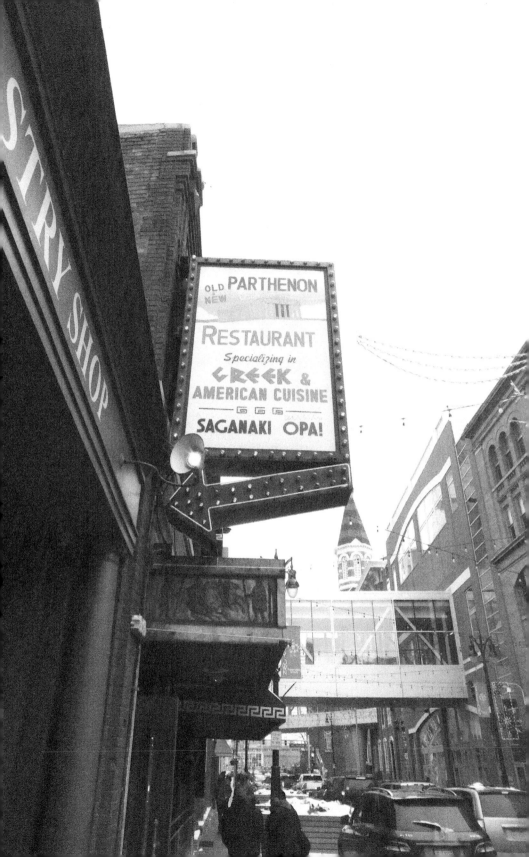

GREEKTOWN

WHY WE WERE THERE THAT DAY AND WHEN WAS IT? I kept thinking for Mama's funeral, but she died long before the People Mover began running. Yet we were in Serman's Men's clothing store on the corner of Broadway and Gratiot for so me reason to buy Daddy a black suit, but definitely not for Mama's funeral along with a lovely woman for him to dance with? Maybe that was why we were so lost about the whole experience of buying a new black formal-looking suit. It was his first date and we were preparing him for it? My son Pedro, who was probably about as old as the People Mover then, my daughter Demecina, a feisty little thing, and I accompanied him to Serman's. OK, we didn't really accompany him. He never would have known where to go; I refused to let him shop at Monkey Wards or Robert Halls (was that still around?) or Federals. Nope, Daddy, we're going to Serman's and get you a good suit. Better than that hand-me-down checkered suit coat you wore to Mama's funeral. We're dressing you up. So we made a selection based on all the sophisticated yaya sales pitch from the Serman's man. And the price was right. Maybe it was Serman himself selling to us. He fitted Daddy while Pedro, Demi and I watched. Daddy stood with composure while the man measured and tucked with pins; Daddy understood the process although he hadn't been in it for years. As I was growing up he praised his doeskin pants, tailor-made in Trinidad; somehow they worked well with the heat over there. I have a picture of a young handsome him in a pair; they fit him nice, real nice. They still hung in his closet.

I can't even remember the season when we were at Serman's. No matter, the suit was not doeskin and it clearly needed alterations. And the day wasn't Trinidad heat. Not much altering, the Serman's man said, but we'll need to kill time while he completed the work. Neither Daddy nor I knew how to do that just then. The Serman man stared at us for a second. I think he surmised that we were confused, that we were in the middle of a major life transaction, a resuiting and we had no idea of where to go while we waited for alterations. I felt embarrassed for us and stared blankly at him. Then he reached in the cash register and pulled out some quarters, almost without skipping a beat, talking fast. Here, go ride the People Mover. It's exciting. You can see all of downtown. By the time you get back, I'll be ready for you.

This was crazy. A highfalutin—at least as far as we were concerned—men's clothing store guy gives us money to ride the People Mover? We shuffled out beholden, now tourists in our own city. Well it was my city and my children's by birth. Daddy owned his piece of it after living and working here since the forties. Originally he hailed from the Trinidad side of Trinidad and Tobago. He adapted better to everything here than his wife of over fifty years. It was always too cold for her in the winter and not friendly enough ever, even in summer. One thing, though, he never became a citizen; neither did she. He said he would never give up citizenship to the place where his navel string was buried. She agreed.

I think it must have been spring. We rode and rode and rode around a downtown you never see from the ground. We were up high and everything was ooh and aah and imagine that. It was tremendously relaxing. No joke. By the time we returned to Serman's and Daddy's suit, we were happy and laughing. We were different people, moving forward.

I've ridden the People Mover on a few occasions since. A couple times to Cobo Hall for the Auto Show, both times in blistering wind and snow. Then to Joe Louis for a Prince concert for my daughter's sixteenth birthday. Her friend came with us. We waved lights to Purple Rain along with the rest of the packed arena. That was my first time waving lights to Prince. The people in front of us were smoking weed. Oops. Maybe I've been on the People Mover an odd once or twice for reasons I can't remember. A couple times I ran into a longtime friend who is a cop on the People Mover. Each time the station was hopping, the cars full.

Now I'm at the Greektown People Mover trying to figure out something relevant to say about it. I can say this is where I'd board these days, if going to Joe Louis or Cobo. Casino people go in and out at this station, dragging cigarette smoke with them. Greektown is two stops over from Broadway. My son and daughter are out west. Daddy got off from the ride about seven years after we first boarded at the Broadway Station. We buried him in the same suit from the Serman's man. I went with a cousin to get a real island-looking bright yellow kerchief and matching tie to firmly identify him as Trinidad though in a black suit. He was always fond of saying, After one time is another. The time of his burial was late September and unusually sunny and warm.

—*Lolita Hernandez*

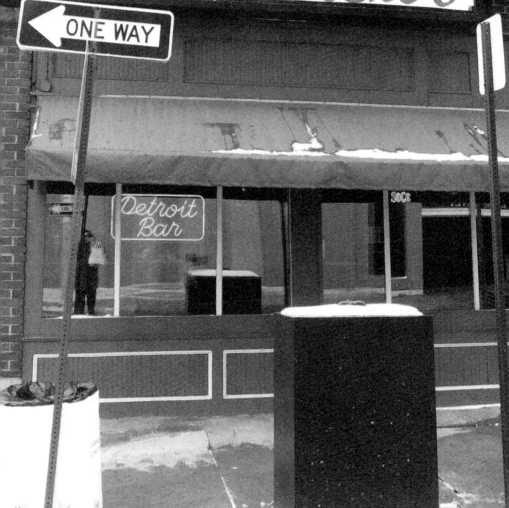

CADILLAC CENTER

SHE ASKED ME TO OPEN MY EYES, and there it was, the small library on Library Street downtown, where we first met. We were standing on the platform of the People Mover station, looking down as the train moved on. I wanted to feel something, anything, but all I could think was, really?

Do you remember what you said? Do you remember what we promised?

I didn't. But I didn't have to say it.

Bobby...I'm trying...

And she was. But it didn't matter. It hadn't for a long time.

Why are you doing this?

Because I wanted you to remember, to remember what we had! What's still here!

She was shaking, and I felt sorry for her, but somehow words came out that I knew would hurt her even more.

You know what I remember? I remember the hip hop club we went to that first weekend, right over there across the street, but now it's a parking lot. I remember us walking past the old Hudson's Building, talking about what we'd do with it if we had the money, but now it's just an empty space. And now, across the street from it is a nice new Compuware building, for new people and new business and...I just wish you'd move on to something new too.

I can't do that, she said. It's not right. And you're not being right!

And that's when it happened.

Looking at her, desperate for me to change my mind, bringing me back to a place that we hadn't revisited for over a decade, I felt it. That distant memory of a relationship that had experienced more ups and downs than made any sense. The feeling that was there before the exhaustion kicked in. Long before the voicemail came that she listened to out of paranoia and proved worse than either of our fears. Back then, I didn't let her come with me because to be honest, we were through long before the message came and I had the meeting. An ugly, short meeting, that I also don't remember past the word

Terminal

I didn't want her to stay with me out of pity or guilt. I guess, in some pitiful way, I still loved her.

Baby, nothing here is the same.

I walked down the stairs and left her on the platform, crying.

—*Cornelius Harris*

"Andre? He got into a fight at work and the Y put him in jail."

IT'S LIGHTLY SNOWING ON A JANUARY MORNING, temperatures are in the mid-20s, and I'm locking my bike under the red X at the Bricktown People Mover Station. There is an official bike rack.

"What's it like biking today?" asks a red-haired woman. She lights a cigarette.

"Ahhh, it's not so bad. My hand is cold. That's about it right now."

I hold up my ungloved right hand. It's pale like a ghost, crispy like a popsicle, and blue-bloody in spots from the finally-here Michigan winter. My bare hand fiddles with the Christmas present U-lock that is ten times harder to manage than my old, nearly broken spin combination lock.

"You got your bike in a good spot, there's a camera right there," says the man with her, pointing.

"Yeah, got an eye on it the whole time," I reply, walking past.

Up ahead, on Beaubien, is that weird under-the-tunnel entrance to Greektown Casino where streets seem to end and a series of one-ways takes the casual driver dangerously close to losing downtown by crossing over 375. Across Beaubien is the Greektown Casino Parking Garage where Greektown Valets run in Timberlands, gloves, and ski hats. To talk, they turned heads, wrapped in scarves, carefully into the wind.

Looking up, I see the green top of the Wayne County Building, the awning at the Detroiter Bar, and Comerica Tower with its diamond shoots pointing skyward. Moving to the left, near the trash can that smells like cold cigarettes, reveals an American flag atop the Guardian Building and snatches of mid-January sun. I catch shreds of the Coleman A. Young Municipal Center and Cadillac Tower. There's Niki's Pizzeria, lofts & studios available, Loco's Tex-Mex Grille, and a tattoo shop.

Next to a collection of newspaper stands, I'm welcomed by two signs. The blue, front door sign says "This Area is Under Video SURVEILLANCE." Another outdoor sign says "Reaching Downtown Destinations in Minutes" and it oozes 2002. The Bricktown People Mover Station has tile that looks like my grandmother's old bathroom. It's gray, slate tile gray; a gray that shows dirt and projects drab. The walls, save a wonderful art piece titled "Bricktown Passage," are filled with outdated paper maps and safety signs. One sign announces "EXPERIENCE DETROIT!" and looks like it was designed in Word 2000. Another sign reads "YOU ARE HERE!" A digital notice above the entrance turnstile projects a notice: "REPORT ALL SUS-

PICIOUS ACTIVITY OR PEOPLE." There are three surveillance cameras.

A woman walks in and kicks snow off her boots.

"Stay warm out there today," she says.

"You too," I shoot back.

She stops to study the only map worth viewing. It's the new kind of Detroit map that you see downtown. It has big, clear arrows pointing in the direction of major destinations, a colorful map below, and a purple legend. The shiny display is bowed-out in a style that invites a hemisphere of readers.

The entrance to the Blue Cross Blue Shield (BCBS) of Michigan Bricktown Customer Service Center, which fuels the traffic and smoking crowd, is labeled with a sign one might see in a Michigan high school gymnasium marking the restrooms. The sign points down a grandmother-gray-tiled corridor that ends in a reception desk. Employees pass back and forth, lighting or getting ready to light a cigarette.

There are maps. There are safety warnings. There are token machines. BCBS is at Home in the D. There are cameras. This is Downtown Detroit during the North American International Auto Show. This is the People Mover.

But there are no people.

It's 8:40am: morning rush hour. In a ten minute span, I see twelve people in the station, and only seven are People Mover riders. One of the seven is a man who reaches over the handicapped entrance gate, lifts the lock, and walks through. The place feels hollow: marked by smokers, slow traffic, and ping-pong sounds from the People Mover.

...

I easily slip three quarters in the slot, prepared specifically for this journey, and pass through the turnstile. The first sign says "January in the D– There's No Place Like It," and I can only think one thought: yes, it's cold, and no one goes outside.

"Bricktown Passage," by artist Glen Michaels, is the highlight of the station. The sprawling piece encompasses thirty-one individual white, glossy panels, each approximately three feet by three feet. The design consists of bars and streamers, the bars like elementary school math fraction rods, and the streamers like a winding race track colored red and orange. Adding

imagination to the creation, race cars fly around the colorful track dodging the black projecting buildings.

It's cold and windy on the open-air station platform. There's a giant, larger-than-life ad for the iPad 2 draped on a building's side. The snow is light powder, the parking lots are just starting to cover, and it's that pleasant, peaceful time during a snowstorm.

I stand by the window, riding above 11-lane Jefferson, and look down at snowy, nobody streets. I float along giant sheets of ice in the Detroit River, through Cobo Center, past Times Square, up to Park Avenue, by the downtown YMCA, and prepare to alight just beyond the Metro PCS Greektown Station.

Back at Bricktown, I'm the only rider who exits. I head straight across Beaubien to the Detroiter Bar, one of the "quaint pubs" described on nearby promotional material.

ESPN plays on the televisions and old sports memorabilia lines the walls. There's a small Friday afternoon lunch crowd.

I grab a seat at the bar next to Mark. His Marlboro cigarettes, old shirt, large beard, and sunken eyes straddle the border of homelessness.

"Where are you coming from?" he asks me.

"Oh, I'm just up the street. I biked down and rode the People Mover around to here. You?"

"Rode the People Mover down here, too."

"Really? Where at?"

"Got on at Times Square and rode over here. I stay up in the Corridor," he says, "been there for years."

"Huh. I'm doing a writing project about the People Mover," I note. "You ride it. What do you think about it?"

"The thing doesn't work right now. It would work if there were bars and clubs at every stop," he says.

"Right," I reply, meekly. The female bartenders smoke cigarettes and exchange stories about making out with old men in casinos.

"It was built when they wanted to cut traffic in downtown. Coleman Young time. Get people to park on the outskirts and ride into work. But it doesn't work any more," he says.

"And plus, downtown Detroit is a giant parking lot. It's like there's some unwritten rule of parking in Detroit that you should be able to get as close

as possible to your destination. So there's no need to park somewhere and get a ride in," I say. "Anyway, I rode my bike today. Best part about biking is the parking spot."

"We got bikes at the place I work at. Guy fixes them up and puts them out front. Puts so much work into each bike," says Mark.

"Yup, it's fun to have a little hobby like that," I joke.

I start packing up my collection of bike gear.

"Well, it was nice meeting you today," I say.

"Yeah, you too," he says.

"I'm sure I'll see you around soon," I reply, walking past.

I head outside, across the street, to the bike rack under the red X. My ungloved right hand fiddles with the key to my Christmas present U-lock. I hop on, follow the colorful Beaubien race track, and weave in and out of the black, projecting downtown buildings. Riding out of the saddle, tongue sticking out to catch fresh snowflakes, I find myself slowly repeating Mark's words: it doesn't work any more.

—*Patrick Morris*

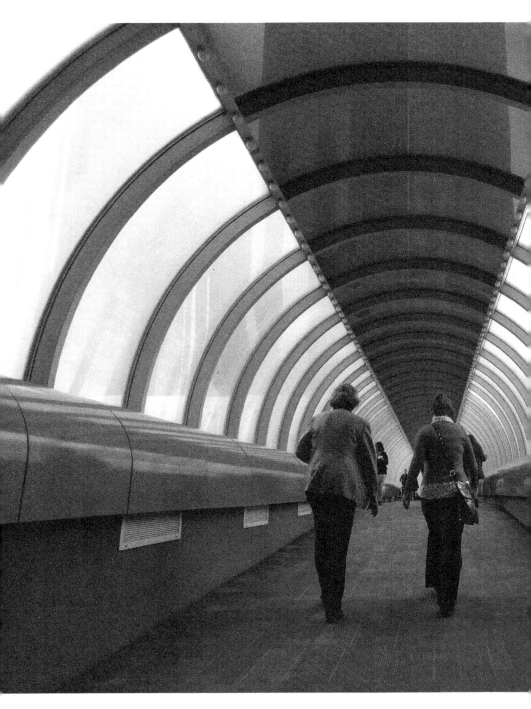

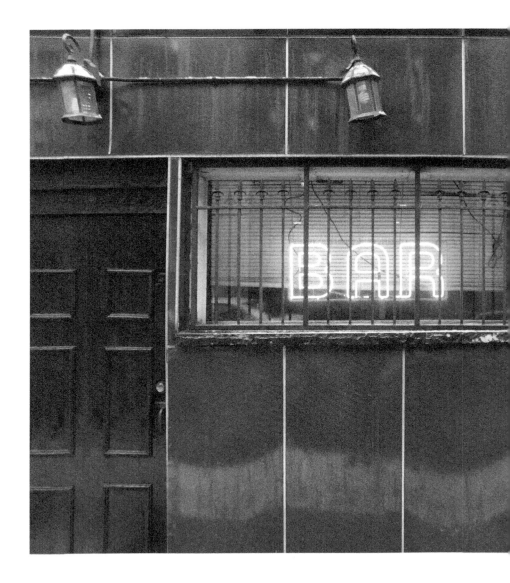

REN CEN ZEN

WHAT I LOVE ABOUT THE PEOPLE MOVER is that you can't board a train going in the wrong direction. There's only one direction. Just a single loop through downtown. If worst comes to worst and you miss your stop, you stay on for another lap. Simple.

I often commute in the PM; it's all second-nature to me. But today my usual routine is interrupted when I realize I have to use the…facilities. So I decide to get off at the next stop, the Renaissance Center. Factoring in the extra token I'd have to buy, I figure it's a seventy-five-cent investment in my comfort.

But it turns out to be more than that.

The simplicity of the People Mover won't help you in the Ren Cen. Upon entering the series of linking-ring buildings, there are signs everywhere and none of them tell me what I want to know. Here, there is a wrong direction, and you can almost assure yourself you're walking in it.

I have to go, and panic sets in. This must be where concrete and old carpet go to die. I can't look at the floor for too long or I get dizzy. I end up walking with my head half-cocked skyward, reading every sign but getting little in the way of helpful information. The numbers begin to blend together in my mind. And…I have to go.

I pass by several Chevys, all painted red. They're a point of reference, maybe, except that there are cars parked everywhere in here.

Then I spot a sign for the food court. Surely there's a bathroom nearby.

An escalator ride down and I'm in fast-food world. I see a woman shoveling the last bite of taco salad into her mouth with a plastic spork. Either she knows there's a restroom in the vicinity or she and her fellow diners are blissfully unaware of the problem they too will soon face.

A sign points me to another sign that leads me down a hall. The familiar hands-by-his-sides guy on the blue square awaits. I made it, and without another second to spare.

I exit, refreshed, and fight the urge to buy a bottle of water, lest I keep myself in this endless loop.

Which is when it hits me: I don't know how to get back to the People Mover.

After circling Level 1 at least three times, I start to get annoyed. Is this really happening again? It's at this point that a young man, couldn't be

much older than 21, comes out of what feels like nowhere and begins walking next to me.

At first I think we're simply walking at a similar pace, but when he keeps his gaze fixed on me, I ask if there's something he needs.

"No, man. I just saw you walking in circles and thought I'd join you," he says calmly.

He must notice my puzzled expression as he offers me a pamphlet as further explanation. Clearly this isn't his first time sidling up next to a stranger.

In a simple font, the cover reads "Ren Cen Zen." He tells me he's the founder and that this is his way of spreading the word. Gesturing to one of many open carpet fields, he tells me "I have a kiosk over there, but people have trouble finding it, so I go out and find them."

I stare back at him, still somewhat confused.

"My dad used to work up on the 12th floor, and whenever I'd come and visit him it was impossible to ignore all the confused people, clearly lost and increasingly disgruntled. Even my dad, an engineer who worked here for 15 years, never completely cracked the code on this place. I figured as long as people are walking in circles, I might as well do what I can to help them calm down."

We chat a little more, he gives me a few tips—"be mindful of your breath," "each step is a gesture"—and I thank him and continue on my way. Or at least continue trying to find my way. Instead of frantically searching, I take it easy this time. My mind is clear, and I'm no longer worrying about the destination. I quietly walk to the center of the atrium on Level 1. New GM products line the innermost ring; have I seen that Volt before?

No matter. I close my eyes, take a deep breath, and envision myself on a one-man train gliding through the Ren Cen, back to the door marked DPM. The feeling is at once unfamiliar and comforting. I know where I have to go, almost as if the People Mover is calling me.

After one wrong turn, I find my way back. I trade a dollar for a quarter and a token. I'm back on the train—any train—headed for home. I'm centered. And all because of a pit stop from one unbroken loop to a series of complex rings. I know I'll be back, and mentally prepared next time.

—By David Gluckman and Zak Rosen

SHRINE CIRCUS

Near this site, on February 26, 1906, some 3,000 spectators watched the nation's first Shrine Circus. Detroit's Moslem Shrine Temple's one-ring show was the beginning of a major fund-raising venture for Shrine temples throughout the country. In 1907 Shrine temples in other cities began sponsoring circuses, and in 1925 the Shriners featured their first three-ring show. Originally operating for one week, Shrine Circuses appear across the nation throughout the year. Clyde Beatty and his wild animals were the main attraction in Detroit from 1925 to 1965. The Nelsons, aerialists and acrobats, and the Romigs, clowns, of Michigan were also featured performers during the early years. In the 1980s annual attendance at Shrine Circuses exceeded that of any other circus in America.

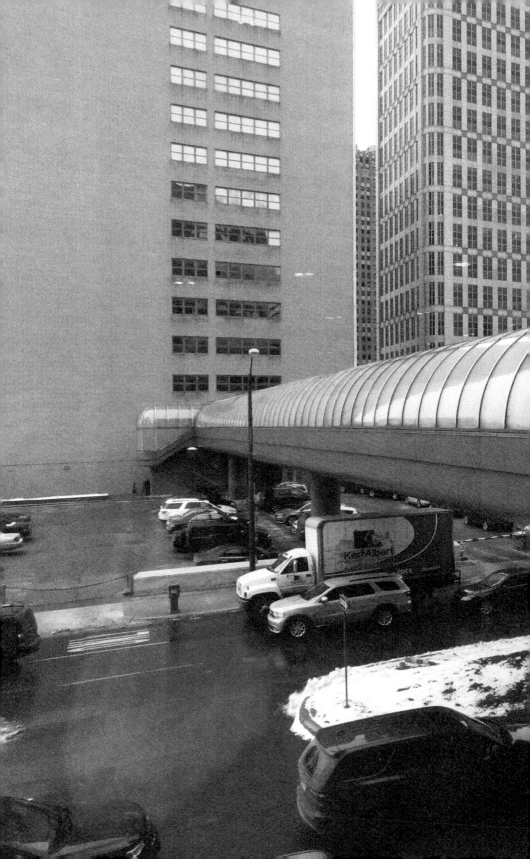

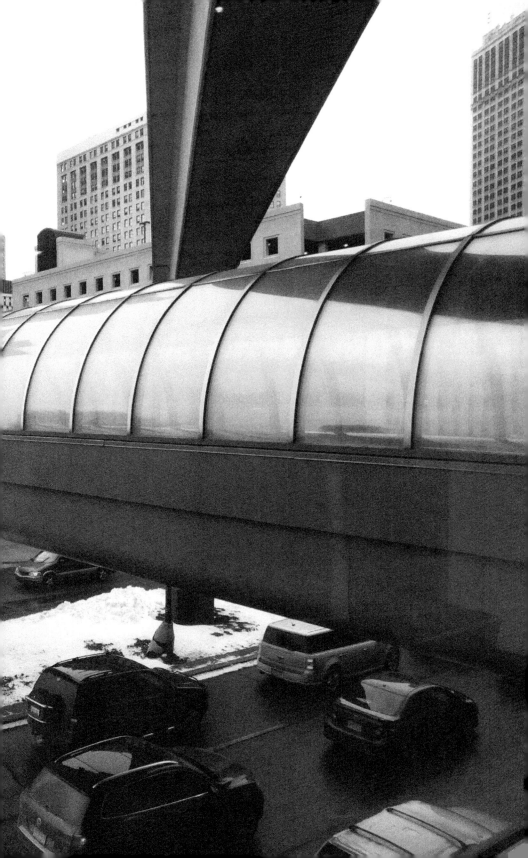

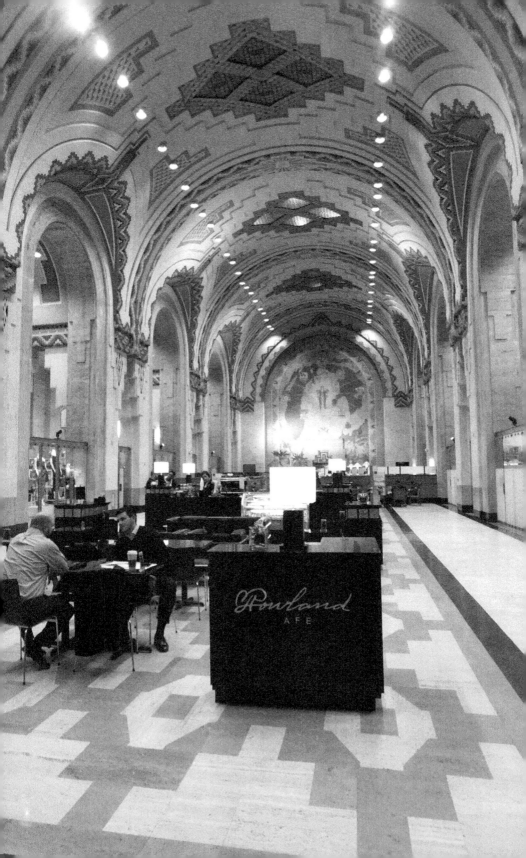

MILLENDER

Oh you junction,
you silent partner
between finance
and renaissance,
you collection
of nerves around
the heart of Detroit
whose name we
lost in history,
you Robert that grew
into Coleman's
jawbone, Conyer's
stamina, gentle stone
goliath down
on Jefferson, you
long road from Mississippi,
new law, of physics broken,
you black history, you
noun-gone-verb-
millendering:
the act of quiet
empowerment of brown
people in a white gravity,
Oh you revolution,
you.

—*Chace MicWrite Morris*

FINANCIAL DISTRICT, SATURDAY MORNING, 1966

SATURDAY MORNINGS WHEN I WAS EIGHT YEARS OLD we were devoted to my bully defense program, which involved my father driving me downtown to Detroit Edison's giant, hidden, twenties-era gymnasium for a company-sponsored session of Father and Son athletics. As an Industrial Photographer for Edison, my father was regularly dispatched into the guts of nuclear plants, lifted by cherry pickers toward the latticed peaks of electrical towers, or plunged deep into the crystalline labyrinth of Detroit's underground salt mine. All part of the job. Other times, he would be assigned to photograph an "All Electric Home!" or even sent to shoot the death site of a victim of accidental electrocution. Whatever the assignment, he loved being out in the field, yet on the weekend he would head into the office in a gentle effort to toughen up his son. We were at that gym to toss around the medicine ball, lift dumbbells, shoot hoops, build confidence, but especially to learn how to box. They had a scaled-down boxing ring there and our Saturdays were often spent trying to get me to learn how to put up my dukes and defend myself against the tough kids who taunted and abused me at Burt Elementary School in Northwest Detroit.

On our way to the gym, my father drove us through Detroit's financial district, where we would stop at *Quikee Donuts* for coffee and a cruller for him, hot chocolate and a nutty donut for me. (Just the thing to have on one's stomach before entering a boxing ring!) Aside from my continuing affection for the nutty donut, that drive into the city is what has stayed with me from that time: my excitement whenever we entered the wide-open, weekend morning streets of downtown Detroit. I, looking up from the passenger seat of our '65 Catalina, would be stunned by the size and beauty of the buildings I viewed. I didn't know their names then, but I do now – the Penobscot building, the Buhl building, the Guardian building. (Thank you, architect Wirt Rowland for those beautiful edifices.)

There was also Yamasaki's Michigan Consolidated Gas Company building, with its white marble panels, whose top floor was illuminated blue at night so to suggest a gemlike hydrocarbon flame. (It housed a penthouse restaurant where my family never dined, but its name even today evokes images for me of thin-lapelled, pill-box hatted, Stinger-swilling sophisticates: *The Top of the Flame*.) What knocked the wind out of me on those Saturdays was the way these buildings carved out the sky, how we drove

through what felt like an obsidian corridor of concrete and granite and marble and limestone and tile, and how the light seemed to barely reach us there in the car.

As for what happened in that gymnasium, I remember those sessions in the ring as unpleasant as best, often tortuous though certainly not violent, since the gloves they gave us boys were so large and unwieldy, it was like boxing with pillows duct-taped to your hands. I recall feeling relieved when the bell would ring and I was allowed to stop. Is it really a surprise that the boxing lessons didn't take? I continued to be a bully magnet, which in turn continued to distress my father. It wasn't until I was an adult that I learned that he had had a bully problem as a child, which was why it hurt him so to see me in the same situation. He did teach me one thing that was better than all the boxing lessons put together: how to meet a bully's gaze without flinching. It was brilliant and worked almost all the time. Once I learned how to look a bully in the eye without looking away, my problems subsided. Eventually nature also provided for me when I grew 7 inches in my thirteenth summer. The bullies decided to move on.

All I really know now is that those Saturday mornings driving around downtown with my father were when I fell in love with cities, and certainly when I fell in love with Detroit, with the idea of this place, this place where they make the cars, where they make beautiful buildings like the Penobscot, the Buhl and the Guardian. Maybe I sensed then that this city, beneath the surface, has always had secret reservoirs of strength, the ability to believe in itself even when no one else could be bothered to, and how even at the worst times, has always been able to stare down the bullies that have abused us. Though I never became much of a brawler, it seemed to help that I was from a place that has always known how to fight back.

—*Michael Zadoorian*

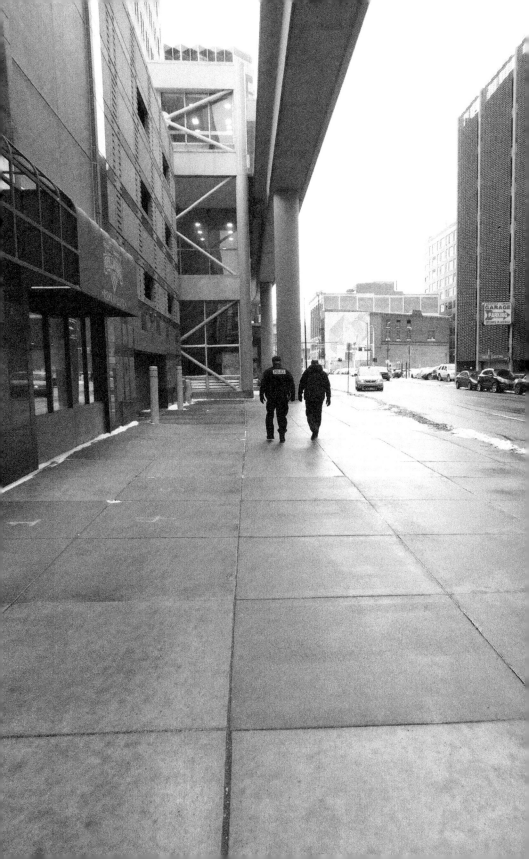

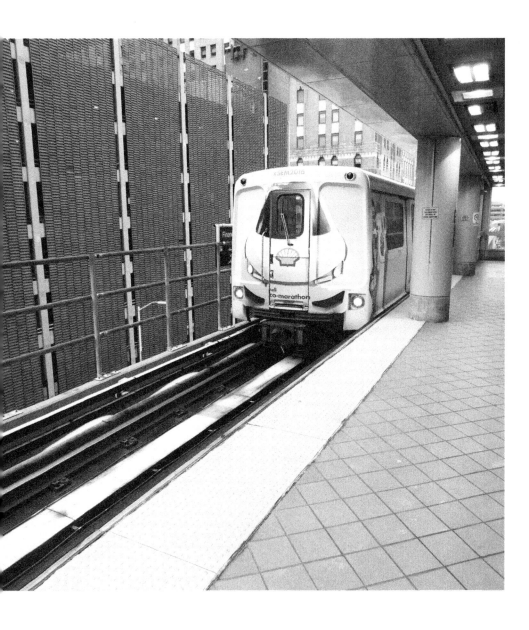

Is it May 21, 1987?
Is Coleman Young still mayor?
the newspaper headlines, held high in the hands of the man in the suit on
the platform at Grand Circus Park say so every day.
That man in the suit never says hello.

Never.

JOE LOUIS ARENA

WHEN I THINK OF THIS HISTORIC ARENA named after this historic icon I remember an NWA concert I attended in 1989 that ended in chaos.

NWA was a Ruthless group (well we thought so back then because that was the name of their record label).

We bought center box seats because we wanted to be up close & personal with the brave, rebellious messengers of freedom.

Well, at least that's how we thought of them at age the tender age of 17.

Downtown Detroit in the 1980's was BIG. It was exciting, electric, bustling. 1989 was a pivotal year because we were entering a new decade. Hip Hop had been an underground thing and now it was this huge thing that mainstream had to pay attention to.

Narratives of the hardships of marginalized folk living in impoverished conditions set to funky pulsating rhythms under the backdrop of emerging developing industrialization is nothing new in Detroit with its rich music history in Motown, Jazz, & Blues.

I remember telling my mom (who grew up in historic Black Bottom and always talked about the legacy of Joe Louis) that NWA was playing there and that I was going to see them.

Now first off, you must understand that my mother is from the civil rights and Black Power era. She lived through the 1967 rebellion, she made sure that every Friday all the other secretaries at her job at General Motors offices ordered Egyptian chicken from The Nation of Islam's then successful Shabazz restaurant, she marched with Dr. King when she was 18 years old when Grace Lee Boggs & Jimmy Boggs brought 125,000 people together for the Walk to Freedom down Woodward Ave (the precursor to the infamous March on Washington), which ended at Cobo Arena right next to Joe Louis Arena.

She would tell me stories that her Father, my Grandfather, a Shriner, 33rd Degree Mason, & Plant Worker told her about the pride Black people felt when Joe Louis "Beat the Nazi's". So when she learned that in the progressive genre of Hip Hop in the modern post civil rights era of the 1980's that young Black Men were self-identifying positively with "The N-Word" it shocked and disturbed her.

And when I told her that I was going to their concert, she questioned

my integrity, so obviously it was no surprise to her when I came home in a frenzy explaining how mayhem broke out when "shots were fired" when they walked out on their groundbreaking song "F the Police".

We later learned that is was firecrackers and we thought it was beef because of their song "Straight Outta Compton" because we heard people yelling "You ain't safe in Detroit, Take Yo Asses back to Compton".

We lived in the New Center Area, off West Grand Blvd & Rosa Parks Blvd aka 12th Street directly across the street from the Motown Museum, where in the 1960's my mother worked as their Accounts Payable Department, she was responsible for making sure everyone received their checks. Although the distance wasn't that far, it seemed like the longest drive ever back to the safety nest.

The ride back home in my homegirl's car was where we recapped the entire situation. Thinking back I remember us being thankful we were all alive. We were right down on the floor in the front and center of the arena when everyone scattered. We were lucky we didn't get trampled. Fortunately we already had a contingency plan that my mom set for us to meet outside at a certain streetlight.

Cell phones were not in popular use at that time, so we literally had to find one another outside among the crowd of thousands looking for their loved ones. It was so traumatic that the memory is forever burned in my brain. I can see and almost hear each moment in still images.

In our living room, Frantically explaining to my mother with Luther Vandross playing on low volume in the background on our super stereo, she interrupted us to ask "How do you think Joe Louis would feel about your experience tonight going to see these N—as With Attitudes who got you out here in these streets running from gunshots and you're not even running for Liberation, you're running for your life over some dumb shit? Do you think he'd be proud of any of you?"

Yeah, that's my Joe Louis Arena memory.

—*Piper Carter*

RED WINGS

I REMEMBER WHEN THE JOE LOUIS ARENA OPENED. It was the talk of the town and I really wanted to go. I started leaving subtle messages through out the house to let my parents know how dead set I was on getting down there to see a hockey game. I put drawings of the Red Wings symbol in the cereal boxes, like a prize, plunging my hand into the box, I'd pull them out and say real loud "Wow, what is this? The Red Wings ?!" I put all the good silverware on the lawn in the form of the Red Wings red wing symbol. After a while, after my mom calmed down about her silverware and we were eating breakfast I was still possessed by the idea of seeing a game, and started chanting, Red Wings, Red Wings, over and over like kids do, and next thing you know I'm standing on the kitchen chair and preaching about the wonders of hockey. I felt like the Ghandi of hockey, or like a pastor preaching to a flock of non-believers. My family still was not interested in watching white people beat each other to get a little puck in a little goal. They felt it was more barbaric then entertainment, and that a young mind should not be influenced by it. This even though my father was a huge wrestling fan. After months of begging and pleading, my parents finally caved and got us tickets to a Red Wings game for my birthday.

The car ride we took downtown was different this time. I felt like Detroit was a whole new world filled with wonders to explore on the way to watch white men on ice hit that puck and each other with their sticks. We passed people getting off the People Mover covered in Red Wings gear some dressed head to toe Wings red and white. After we finally found a place without a meter to park, we had to walk a couple of miles. Downtown was empty, but nearer the arena it was crowded that night. On the way, we passed two Coney Islands. I couldn't understand why they put two restaurants with exactly the same thing on the menu right next too each other. After walking, for years I said, we were finally there. I had a Rocky Balboa moment and ran up the stairs like I'm preparing for the biggest fight of my life, pumped my fists when I got to the top, because we were sitting in the nosebleed seats, but I was so happy it didn't matter. I couldn't recall the woman's name who sung the national anthem, but she had that kind of quivering opera voice. It was a symphony for the soul just before,

you know, the skating and beating began. Once the game began the crowd was roaring for the Red Wings. I saw different races connecting in a way I never thought possible. Hugging, chest bumping, spilling beer on each others shoes without getting angry. I mean even people from overseas were there. At that very moment life isn't defined by race, just by love of Red Wings (and not love for the other team, but I can not remember who that was now).

I'd like to do the same thing with my children, take them down to the Joe, see a game—I'd say at minimum, count on seeing the Red Wings at least 4 times a season. The two Coney Islands are still there, but the city is changing. Parking, for one, is way more expensive, almost as much as my birthday tickets were back then on game day.

— *Brie McGee*

Maybe there's an ad in there for
Phenomenal Nails by Chiketa or Little Foxes Fine Gifts, or one of the
other attractions at the next stop that may or may not be any longer.

(Is it the same bird that races the train past Joe Louis?
The bird that will always pull ahead and keeps going just as we disappear
into the tunnel before Cobo? It looks like fun that bird is having.)

A CAVALCADE FOR A RENAISSANCE

*Inspired by Cavalcade of Cars, Larry Ebel & Linda Cianciolo Scarlett

Venetian glass mosaic frame
Memories of my childhood,
Arms resting on the window pane
My eyes gaze into the summer's light
I envision a time before I began to understand winter
A time when my city was alive
Thriving on the strength of muscle cars
America's backbone,
A bastion of industry,
The fortified spirit of assembly line workers
My city
Thunderbirds cruising Woodward Avenue
Fathers and sons work the plant in River Rouge
Revolution and innovation,
Paris of the Midwest, it was once hailed
Finely crafted architecture, a city of homes
Precise engineering, well-oiled machines
Engines revved up, we rolling in style
Luxury slowly transforms into need
The people once loved us for the Model T
And championed my city "The arsenal of democracy"
How fickle are fans and critics alike?
How quickly do the teeth of history bite?
Venetian glass mosaic frame
You've stirred the echoes of ghosts in this place
I can't help but wonder if the images I see are an ode to past glory,
Or a warning to heed
Freeway construction destroyed Black communities
Suburbs exacerbated the racism and hate
Deep are the roots in Detroit of both shades
Neither of the pawns recognizing the play
Abandoned homes
I counted 21 after viewing the Cavalcade

In a 3 minute bus ride from Dexter at Northwestern
To Dexter at Joy Road
However, there is no pity
Only desperate hunger, a healthy anger, boiling passion, and unconditional love
America you raped Detroit,
Our streets bare the toll of the mythology of the Second War,
Bigotry at home,
False democracy and expansion of the empire abroad
But we will endure,
Rock solid, Joe Louis fist raised in defiance
High as Yzerman hoisting Lord Stanley's Cup for the first time
I hear the voices of Blackbottom,
The casualties of the '67 riots
The celebration of the '68 Tigers
Hard hats, tough skin
Ben Wallace and Isaiah Thomas
Endurance and undying spirit
Grace Boggs, William Copeland, Anita Peek
Our fallen, which are no longer with us
Aiyana Stanley-Jones, Kenneth Lucas, Malice Green, Samuel Williams
We march on
Anticipating our renaissance
Out from the bitter cold of winter
Rising from the ashes
Detroit, you will come alive again
And I will be along for the ride

—*Walter Lacy*

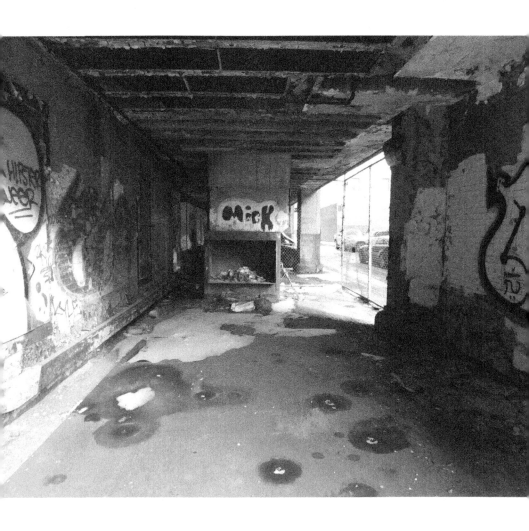

93

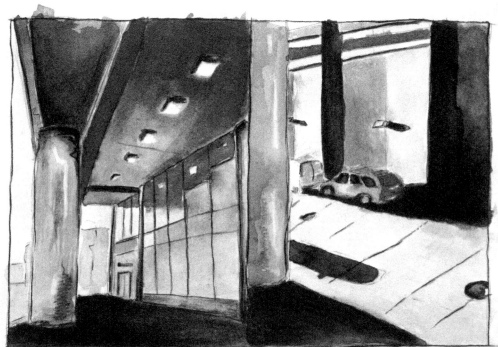

I HEAR THE TRAIN DISAPPEAR INTO THE DISTANCE AS I EXIT THE STATION ONTO AN EMPTY SIDEWALK, DARK FROM THE SHADOW OF THE TRACKS ABOVE. WALKING NORTH A FEW STEPS — TO MY LEFT, AN ALLEY FLOODED WITH LIGHT.

— *Charlie Michaels*

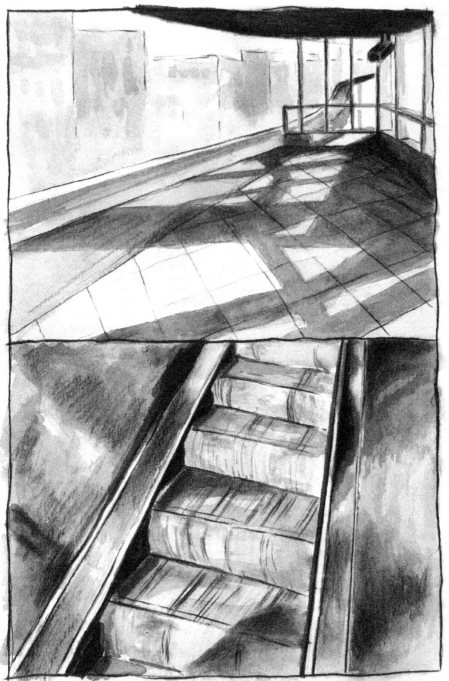

FORT/CASS STATION. IT'S EMPTINESS DRAWS MY ATTENTION TO DETAILS
OTHERWISE UNNOTICED. SLOWLY CHANGING LIGHT & SHADOW PATTERNS RECORDED
ALL DAY BY A SECURITY CAMERA & THE ESCLATOR'S MECHANICAL ECHO. IT'S
PRESENCE IMPLIES A BUSTLE THAT DOESN'T EXIST.

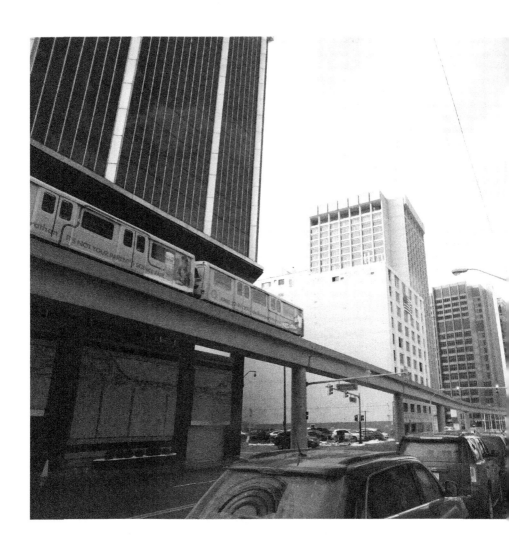

Don't get off just yet…

Because it's almost 1 p.m. and the sign says they will return at Al Hilal Books and Imports.

Beware of Activity the sign says.
What might happen?

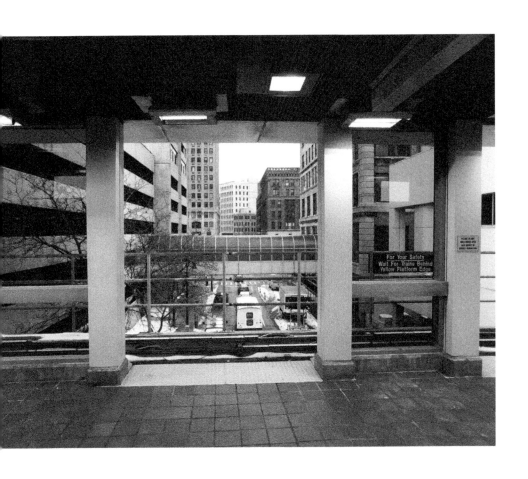

THE LITTLE TRAIN THAT COULDN'T

"WE'LL TAKE YOU THERE!"

In 1987, the People Mover began chasing its own tail. Still, today, the poor thing continues to circle and circle, failing to come to terms with its own impotence.

Amongst Detroiters, the People Mover inspires a unique degree of disdain. Consistent in my small and utterly un-scientific sample is how people from Detroit think of the People Mover as an embarrassment or a joke. In essence, it's a monorail without Mickey or a roller coaster at the end. It also pokes at something many Detroiters abhor—pathetic attempts at making the city cosmopolitan. Detroit is not a glamorous place and most of us are at peace with that.

How can one lil' train evoke so much anger? The People Mover has one line. It loops without deviation, without expansion, without variation. When Mayor Coleman A. Young released plans for the project, he may have actually believed that the "mugger mover" would help downtown economic development, but the people were quick to recognize the fallacy. City governments do what city governments know. Creating a limited-service train system has, apparently, *worked* for some cities, and for many amusement parks.

"MICHIGAN AVE. STATION. LOCATION: CORNER OF MICHIGAN AND CASS AVENUES"

As a young person, the bars of Michigan Avenue lured me in. The romance of gaudy year-round Christmas lights and empty cobblestone streets beckoned; the older folks captivated. Hearing stories about their Detroit—from tall tales of the glory days of Union labor to war stories about how tough each bar patron's neighborhood was—kept this young audience rapt. Michigan Ave. boasted the Gaelic League, the Maltese-American Club, the Kress Lounge, the Lager House and myriad other places to forget one's own little problems while getting a cultural history lesson. These glimmers of cityhood meant a lot to those of us who grew up feeling like scrubs from Chicago's grittier, less-functional cousin.

"HERE'S THE BEST WAY TO DISCOVER DOWNTOWN DETROIT!"

Following a breakup in my early 20s, I drove around the city on Christmas Eve. Crying hysterically, and I do mean hysterically, the acute pain of unadulterated heartbreak took over.

Realizing there was no reason to go home, and that doing so would only make being alone harder, I drove circles around Corktown and Southwest Detroit passing places I had visited with my beloved just to make it hurt more. Driving through puffs of condensation mushrooming out from the sewer grates, I cried my face off. During this time—the late '90s—it didn't feel unsafe to drive with eyes too flooded to see, because there were seldom obstructions *to* see.

"QUICKLY, EASILY & SAFELY CONNECT TO ALL THE EXCITEMENT!"

This city, The City, inspires youthful dreams. Then, as we learn about the world our little hearts get broken, our spirits crushed and our minds often pickled by cynicism or boredom. The romance fades. Those twinkling strands of light become dusty and tired, like the old men who tend bar along Michigan Ave. Maybe adulthood is, by definition, a state where the sadness of the everyday has penetrated our consciousness and diminished some of life's magic; a state for coping with this world.

Eventually though, resilient creatures that we are, we scab over, heal, fall in love and open up to be hurt all over again. Tired of circling, madly, circling and in search of a new pattern, I move away at the millennium's infancy.

"TAKE A BREAK AND ENJOY A DETROIT CONEY ISLAND HOT DOG WITH THE WORKS AT ONE OF THE SEVERAL EATERIES ALONG MICHIGAN AVENUE."

Returning to Detroit in the summer of 2011, the "downtown bobsled" still whirls in circles. The determined creature continues its pursuit, despite often doing so without any cargo. I explore the new businesses on Michigan Ave. Blown-out storefronts have become yuppie mainstays (there are yuppies here!?). Rave checkpoints from the '90s have become above-the-board businesses and unoccupied buildings transformed into new somethings

These changes evoke contradictory feelings, but the loudest is the importance of resisting tried cycles of gentrification. Instead of perpetuating the sort of cultural and economic apartheid that exists in cities, like Chicago and San Diego, we must connect. Radical re-thinking of how a city/person/ society functions is a scary thing, and one that Detroit must do in order to avoid another "train to nowhere".

"AT THE CORNER OF MICHIGAN AVENUE AND WASHINGTON BLVD. STANDS A STATUE OF GEN. ALEXANDER MACOMB WHO FOUGHT IN THE WAR OF 1812. HIS FAMILY OWNED MOST OF MACOMB COUNTY, GROSSE ILE AND BELLE ISLE."

Gen. Alexander Macomb and his boys did a fine job of wiping out the local color of the places he *owned*. Two hundred years later, the same conversations are looping around things like Hantz Farms, where a businessman proposes investing $30 million over 10 years to create the largest urban farm in the world in southeastern Detroit.

"THE FUTURE ROSA PARKS DOWNTOWN DETROIT TRANSIT CENTER (SUMMER, 2009) WILL BE LOCATED STEPS AWAY FROM THE STATION."

In the distance, in spite of the outdated text on the People Mover's website, the Rosa Parks Downtown Detroit Transit Center glistens. This is a place that takes actual people to actual places.

"OUR GOAL AT THE DETROIT TRANSPORTATION CORPORATION IS TO PROVIDE PATRONS WITH THE SAFEST AND MOST EFFICIENT METHOD OF RAIL TRANSPORTATION AVAILABLE. THE DETROIT PEOPLE MOVER SYSTEM OPERATES ON A DAILY BASIS IN THE DOWNTOWN DETROIT CENTRAL BUSINESS DISTRICT."

It's comfortable to function without self-evaluation. The People Mover in 2015, is a reminder of the need for creativity and fresh thinking. Citizens, planners and entrepreneurs, who aren't afraid to deviate from established patterns; be free to create new forms. Just no more L7s, or perpetual circles, please.

—Katie Grace McGowan

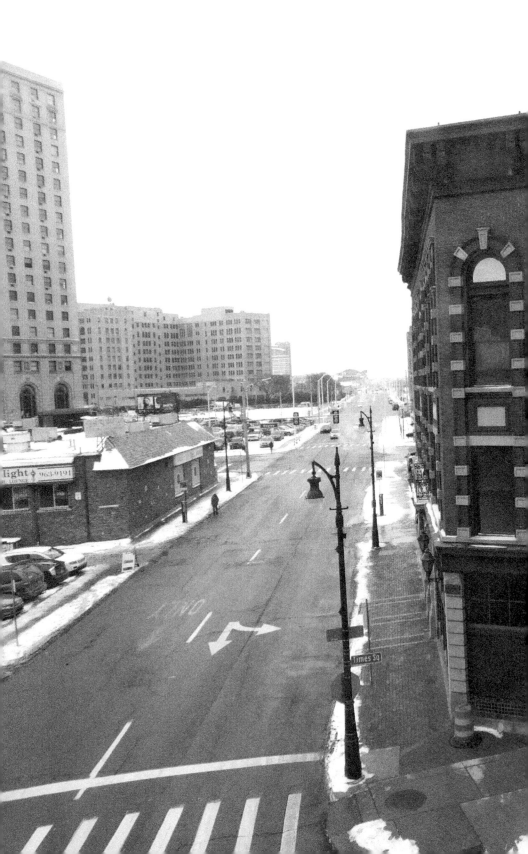

TIMES SQUARE

Here the people mover dips down,
snaking through the air,
pass the roaring 20s grandeur
of the Guardian Building and Penobscot,
icons of an era of opulence—
dips and shudders to a stop
where Grand River meets Times Square:
Not bustling.
Not posh.
No neon lights.
Nothing chic.

First the shock
of seven steel masts
and a canopy of colorless sails,
the outlandishly airborne design
of the Rosa Parks Transit Center.
Then an expanse of evacuated concrete.
Center downstage, Nick's Gaslight Bar, all red and weathered.
Upstage right, a faded, whiskered monolith, the Leland Hotel,
and at Bagley and Michigan, the marble fortress of AT&T.

On the platform,
the patina of tile mosaics
polishing the Cadillac and Millender Stations
is missing.
Nothing shining
to greet those who exit here,
who scramble to street level
and wait for the buses or
scamper away from the bleak space.

Do you come to visit sometimes, Mrs. Parks,
float in to sit among the huddled,
lament the dispossession they are resisting
as the wealthy deconstruct
and recast the City to suit themselves?

Times Square Station:
Site for waiting and moving on.
Not bustling.
Not posh.
No neon lights.
Nothing chic.

 —Gloria House (aka Aneb Kgositsile)

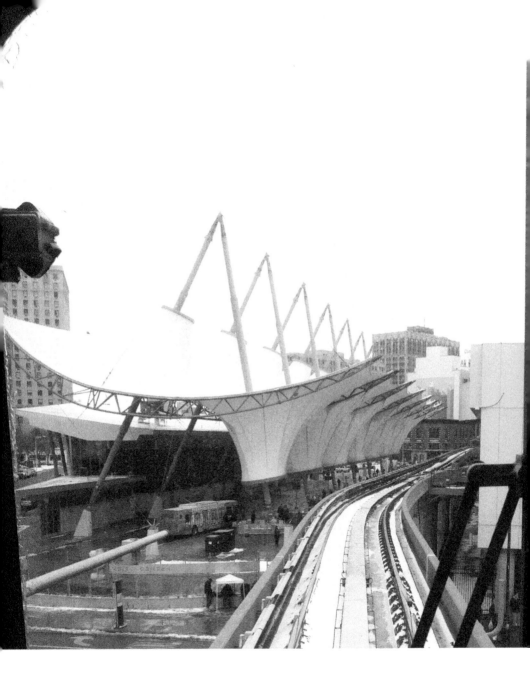

The chain link fences blocking the entry to The International Club on
Clifford or the Park Restaurant will soon be rolled up, the bones of their old
haunts stripped bare to be built out for "creative living downtown."

Maybe later, the one-legged dude in the wheelchair won't be staring as you read that evacuation of wheelchairs is not possible.

Maybe this next time when the journey becomes a series of tangents, you can follow the blue line down the middle, where Detroit's rapid transit loop feels most like entertainment and seems to lift off. Maybe with enough velocity, jump the river and go straight to Caesers Casino in Windsor, Canadian lights blinking their greeting.

Soon it will by May 1987 again.

The storefront podiatrist with his corrective shoes in the window will look out onto Washington and wait for bunions and corns to hobble off, take a load off in the politely padded stalls that look like mini confessionals while they wait. Watch the red Elmo figures go around again.

Maybe not today either.

"Beware of suspicious people and activity" the sign reads on the platform at Grand Circus Park, where, according to the bronze newspaper held by the stand in for a commuter, apparently, it is always 1987.

PEOPLE MOVER STATION STOPS:

GRAND CIRCUS PARK
Mary Lum

BROADWAY
Stacey Malasky

CADILLAC CENTER
Cornelius Harris

GREEKTOWN
Lolita Hernandez

BRICKTOWN
Patrick Morris

RENAISSANCE CENTER
Zak Rosen & David Gluckman

MILLENDER CENTER
Chace MicWrite Morris

FINANCIAL DISTRICT
Michael Zardoorian

JOE LOUIS ARENA
Brie McGee
Piper Carter

COBO CENTER
Walter Lacy

FORT/CASS
Charlie Michaels

MICHIGAN AVENUE
Katie Grace McGowan

TIMES SQUARE
Gloria House

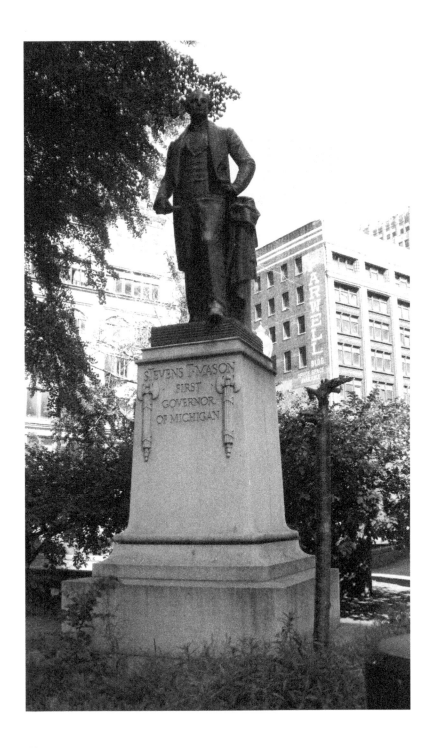

POST SCRIPT

I STARTED RIDING THE PEOPLE MOVER THIS WAY—in 2005, with a group of fourth grade Detroit Public School students. It was our field trip. Everyone got two tokens. At the time, downtown was seemingly empty from the elevated view we had through the train windows. We peeked in the Wurlitzer building, the Whitney, the Book Hotel. We went around and around, then stopped at Grand Circus Park and, finding the fountain at the center dry and not working, made our way to nearby Capitol Park, where the buses came in and out. Capitol Park had been the site of Michigan's first state capitol—with a monument to the first governor, Stevens T. Mason, to prove it. We ate our bag lunches by this man's statue, surrounded by a few party stores, check-cashing places, and the backs of parking garages.

Today, a startling number of those places are gone save the backs of the parking garages. Capitol Park, like Grand Circus Park, is poised between that past Detroit and the post-bankruptcy city, with longtime residents now being pushed out of downtown conversions, displacing older residents to high-end affluence: the reopened Book Cadillac Hotel, outcroppings of luxury retail, craft beer on Broadway, and tech startups in the Whitney building. The ground circumscribed by the elevated line still resembles the city the suburbs sought to avoid, but its future is precarious, and as the bars and bakeries on the ground find their leases up, their presences become occupied by unfamiliar faces and voices, leaving entire communities and cultures displaced.

The promise of the People Mover as public infrastructure was to start a transit system downtown linked to a larger transit network that would serve the greater city. Detroit is still waiting on that promise and, at present, has funneled 140 million dollars into a largely privately funded 3.3 mile streetcar line: the M1. The M1 will serve the Woodward Avenue spine—the corridor from the Detroit River up to the New Center area—already the most heavily invested slice of the city with corporate anchors from Quicken Loans and Fiat Chrysler, Whole Foods, Wayne State University, the Detroit Medical Complex, and new constructions of loft-style living.

While a Reagan administration transit chief predicted that the Detroit People Mover could become "the least cost-effective transit project in the last 20 years," we are in many ways entering a similar agreement with the M1. While the vast majority of population and area is outside both the People Mover loop and the M1 line—waiting instead for public buses—the people may still not be moved by this transit project, but the city is moving.